1979 Kawasaki KZ1000

Handmade:
Frame
Seatpan
Sissybar
Brackets
Gas tank
Handlebars

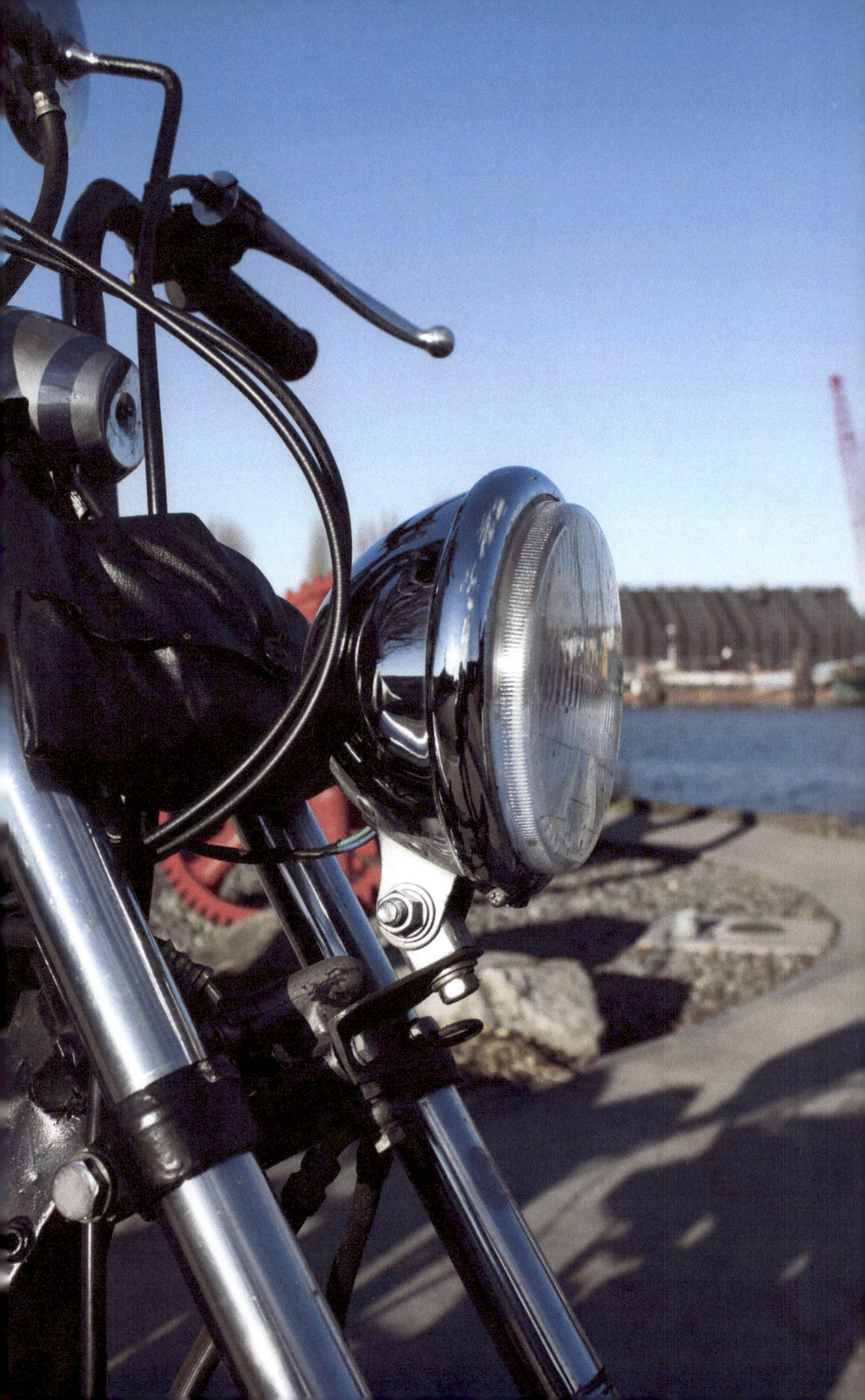

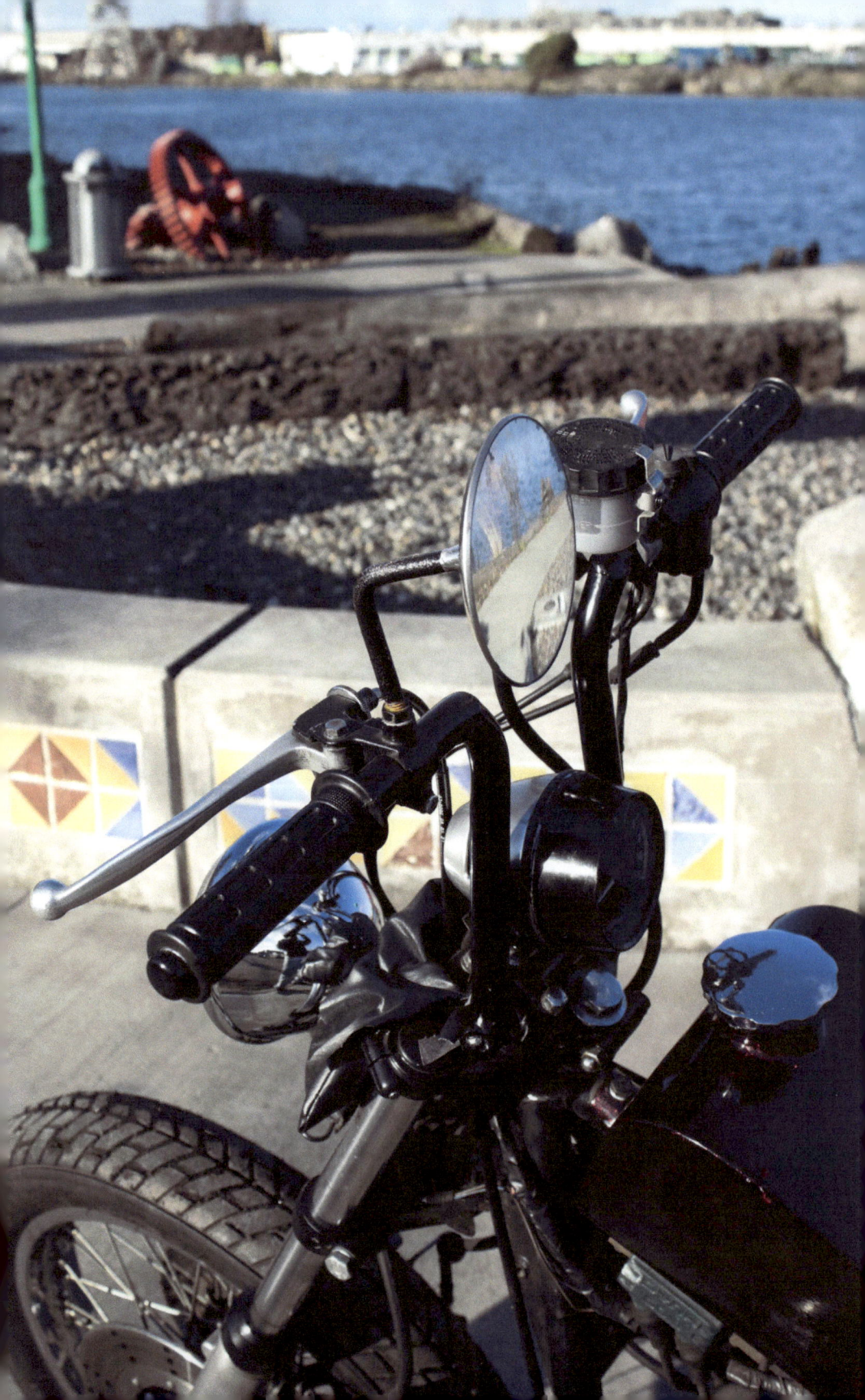

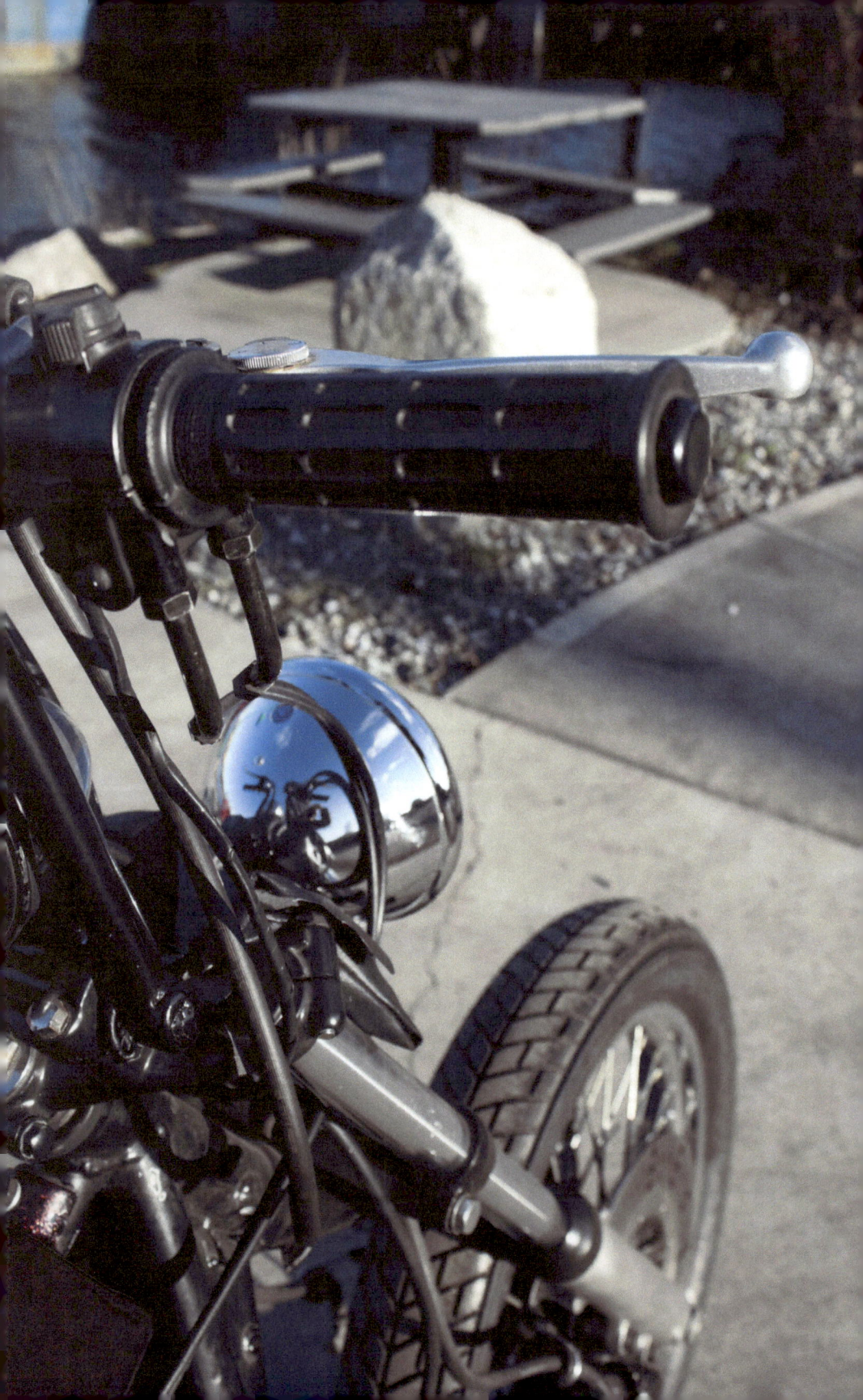

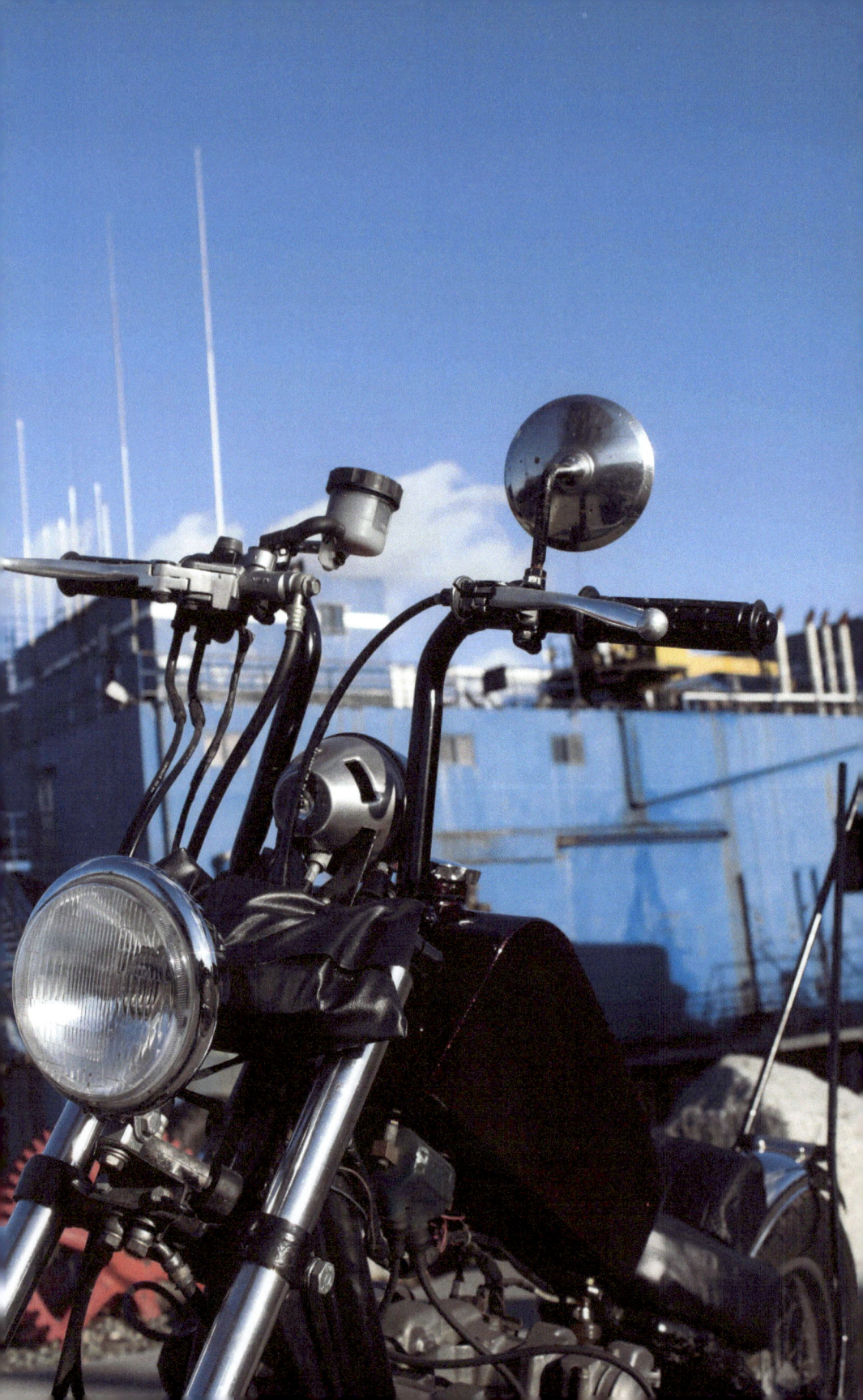

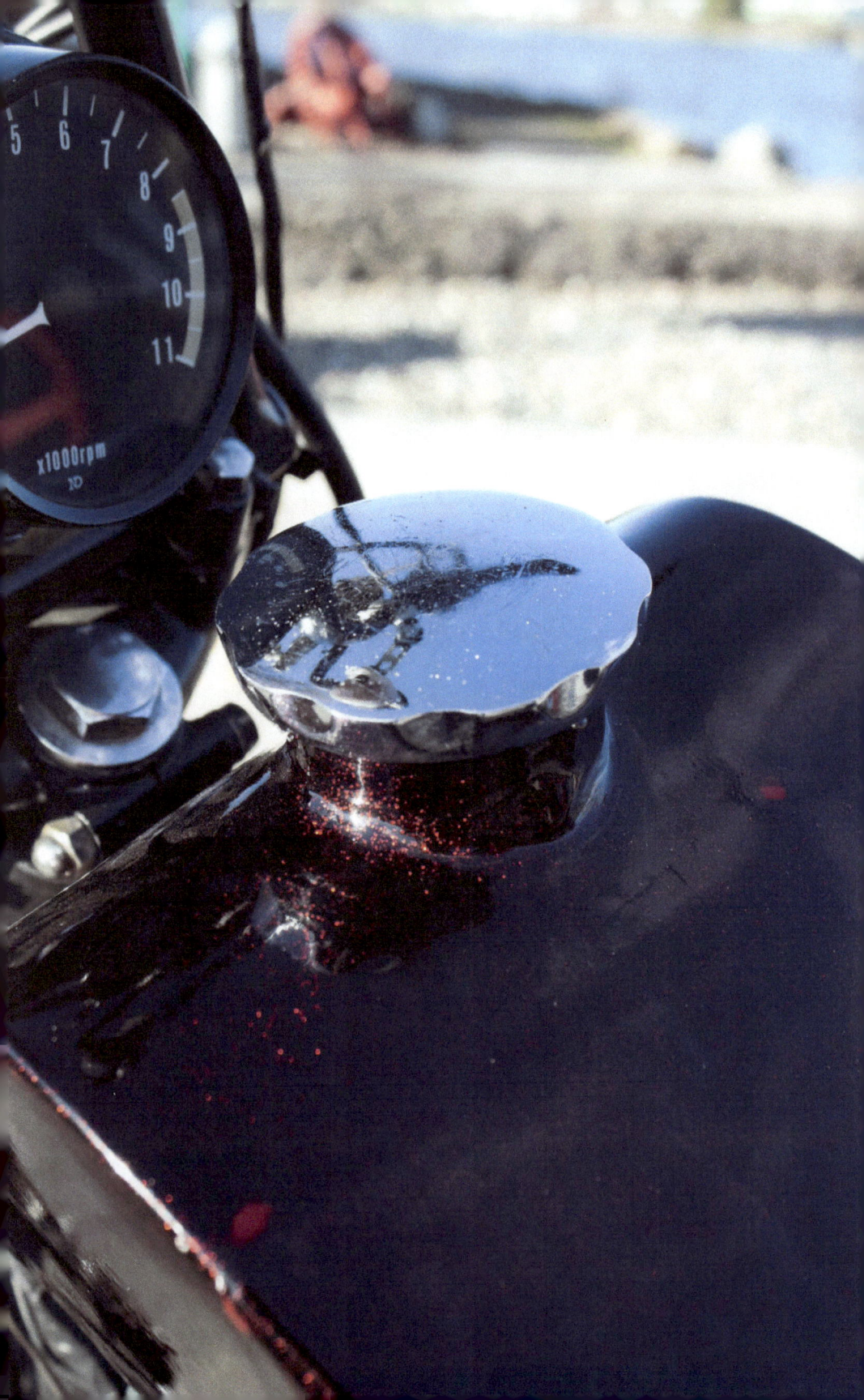

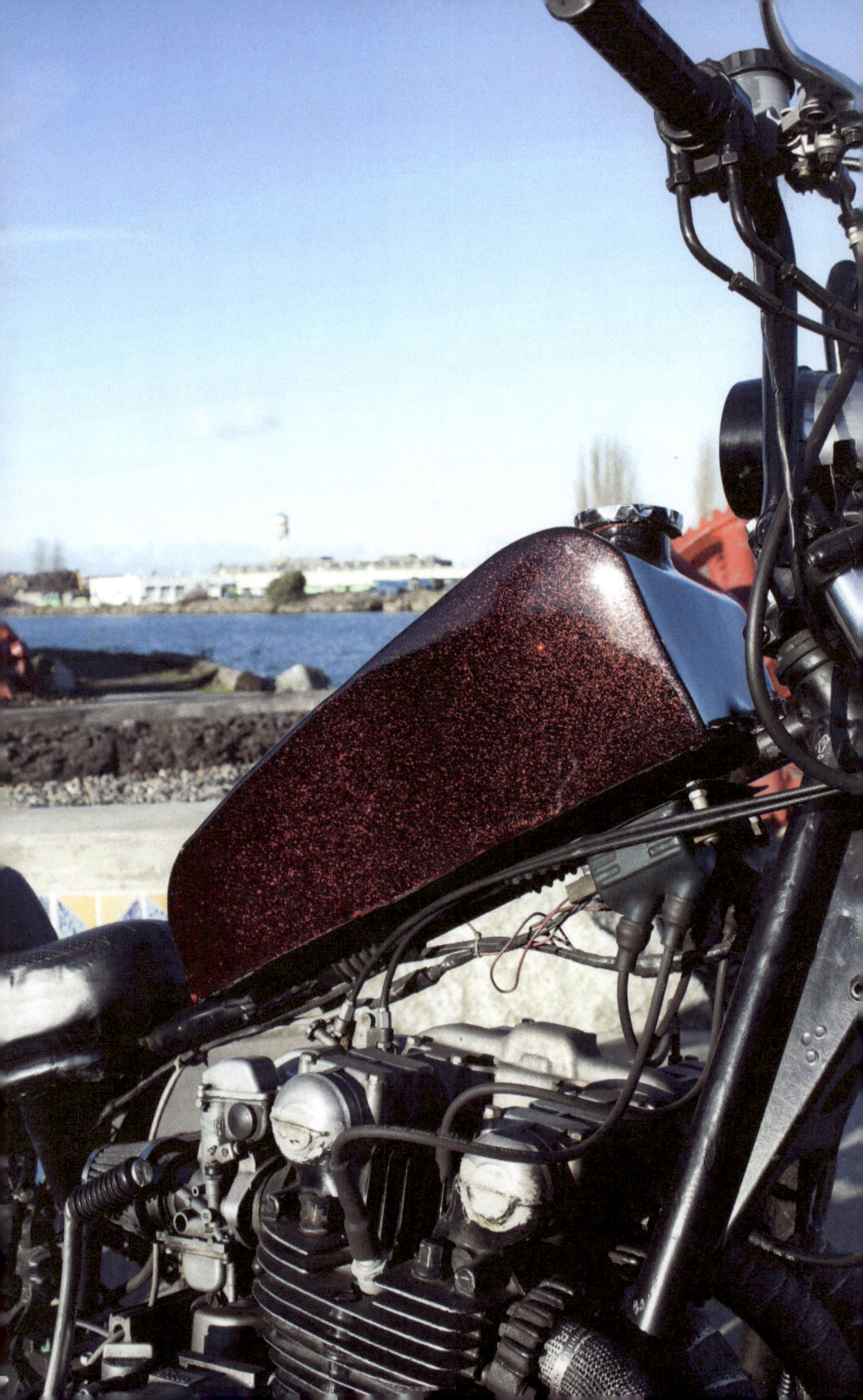

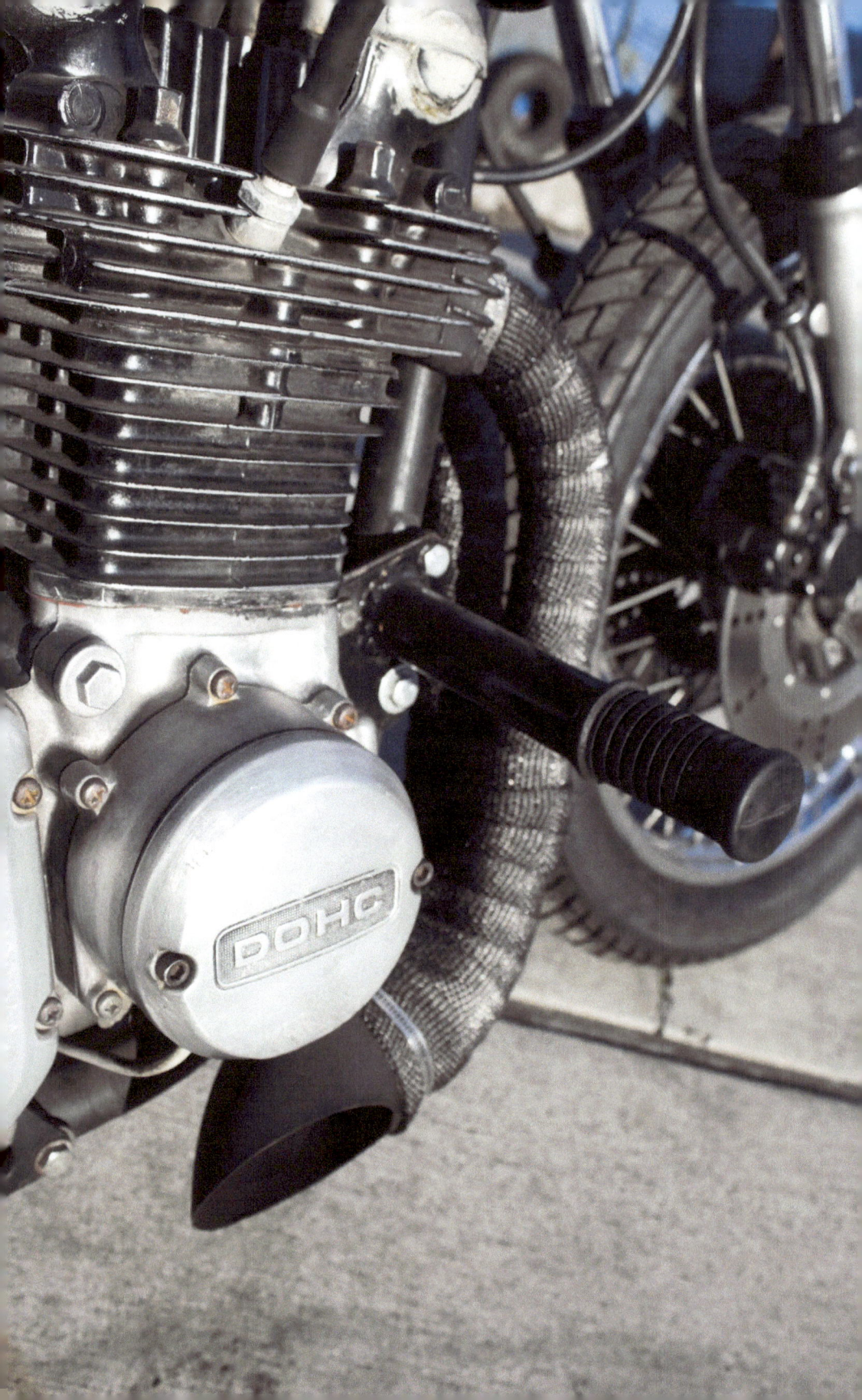

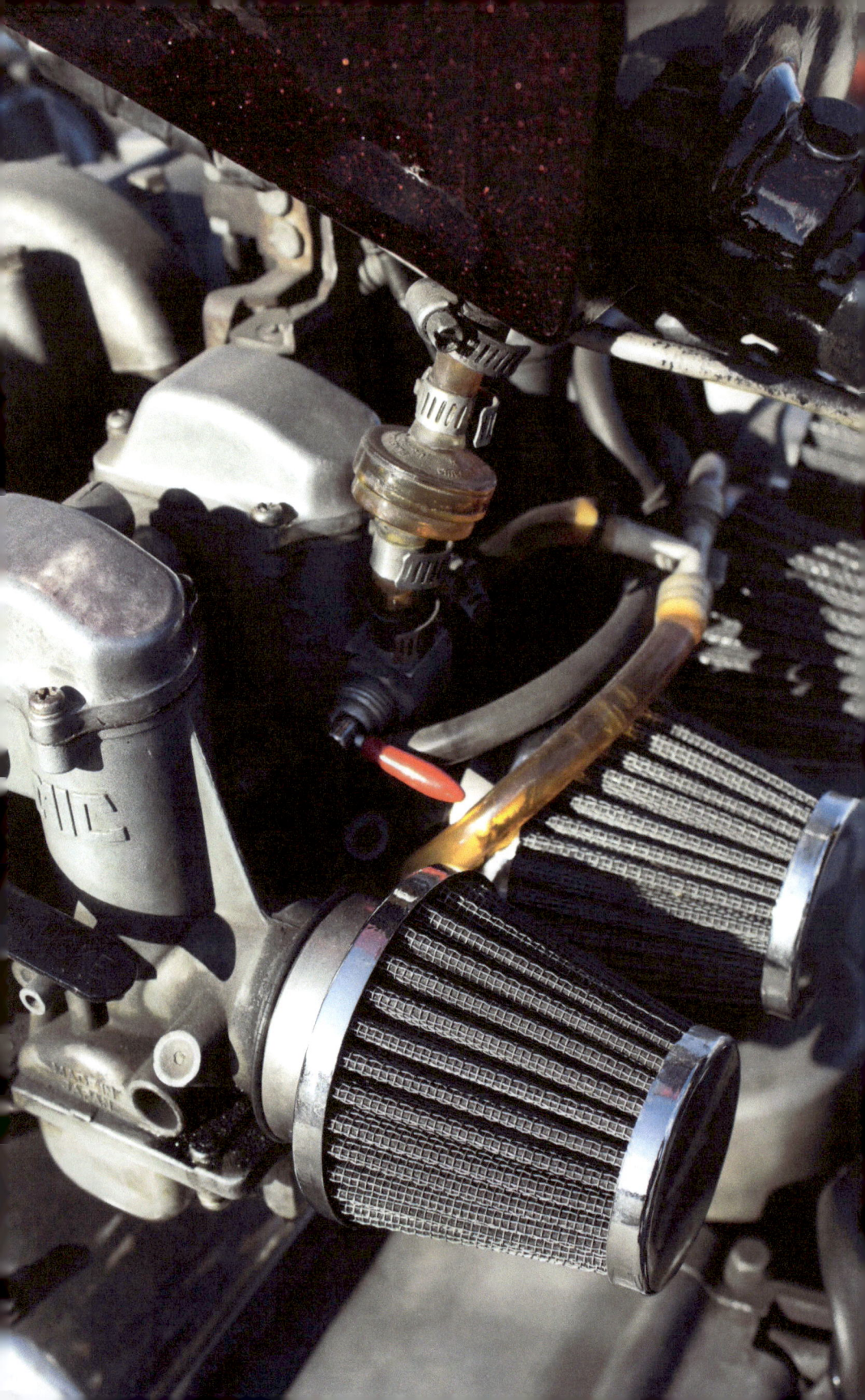

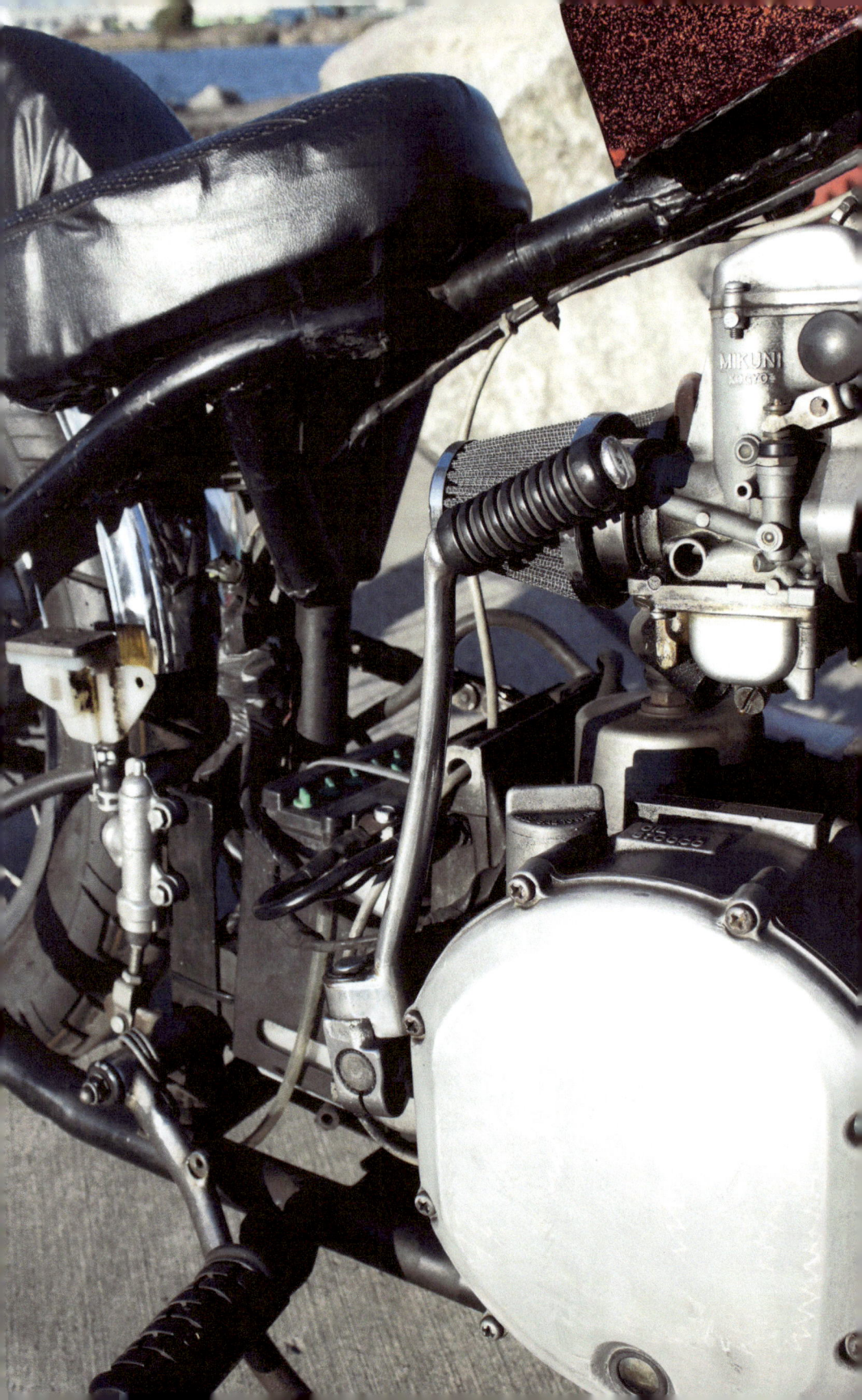

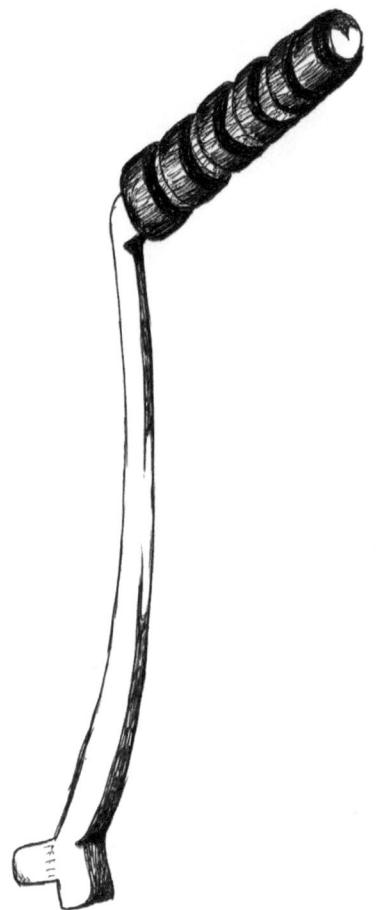

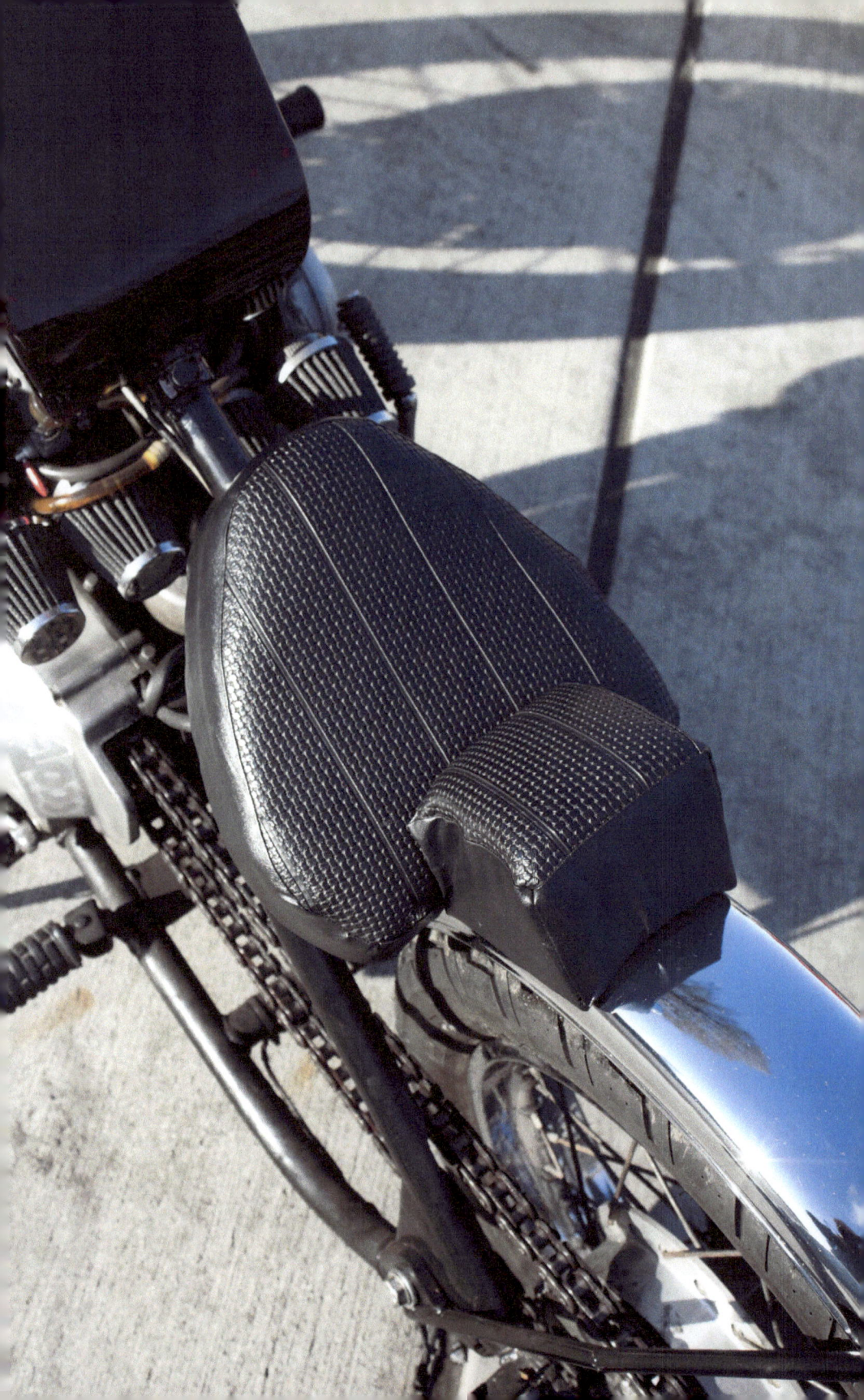

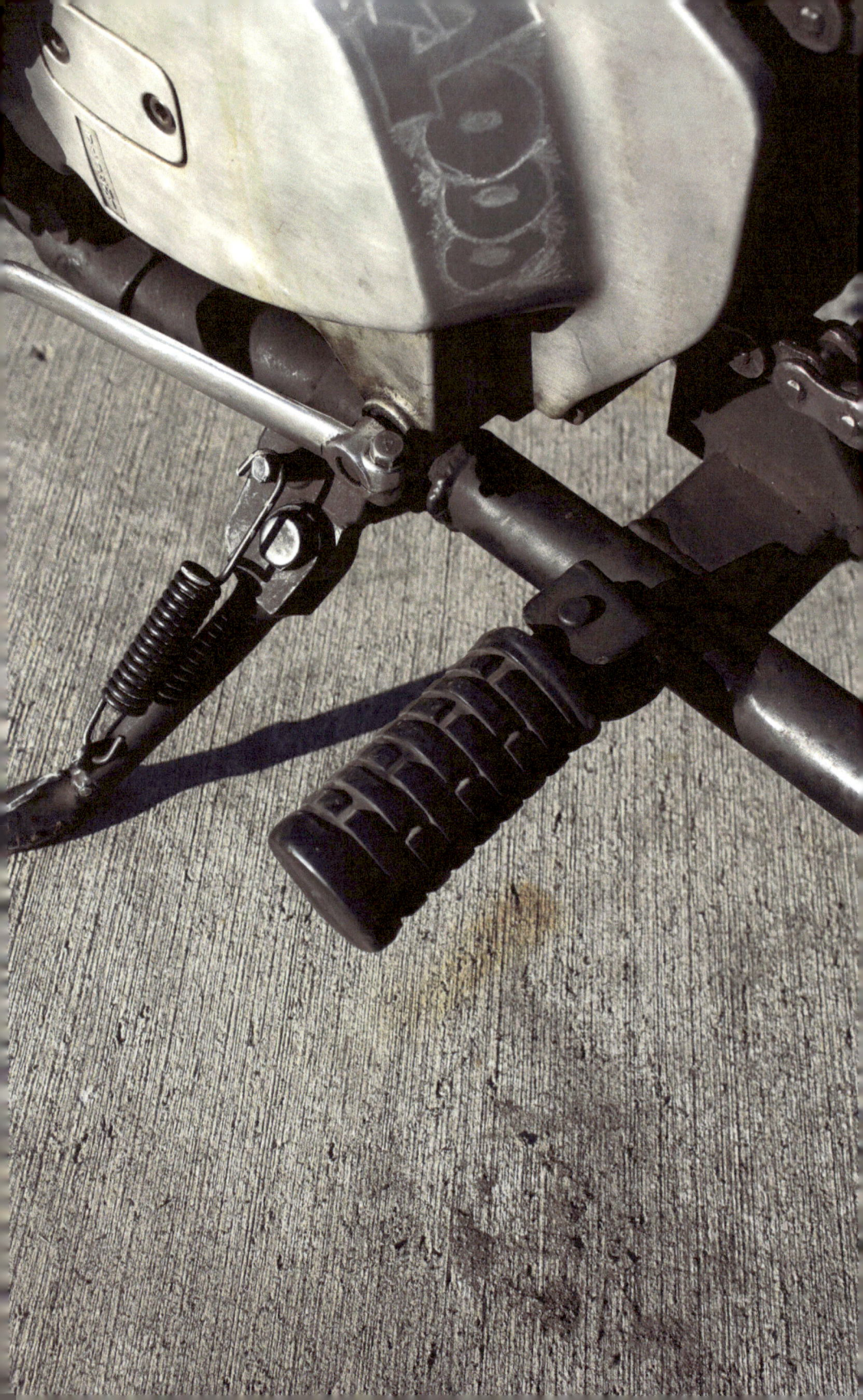

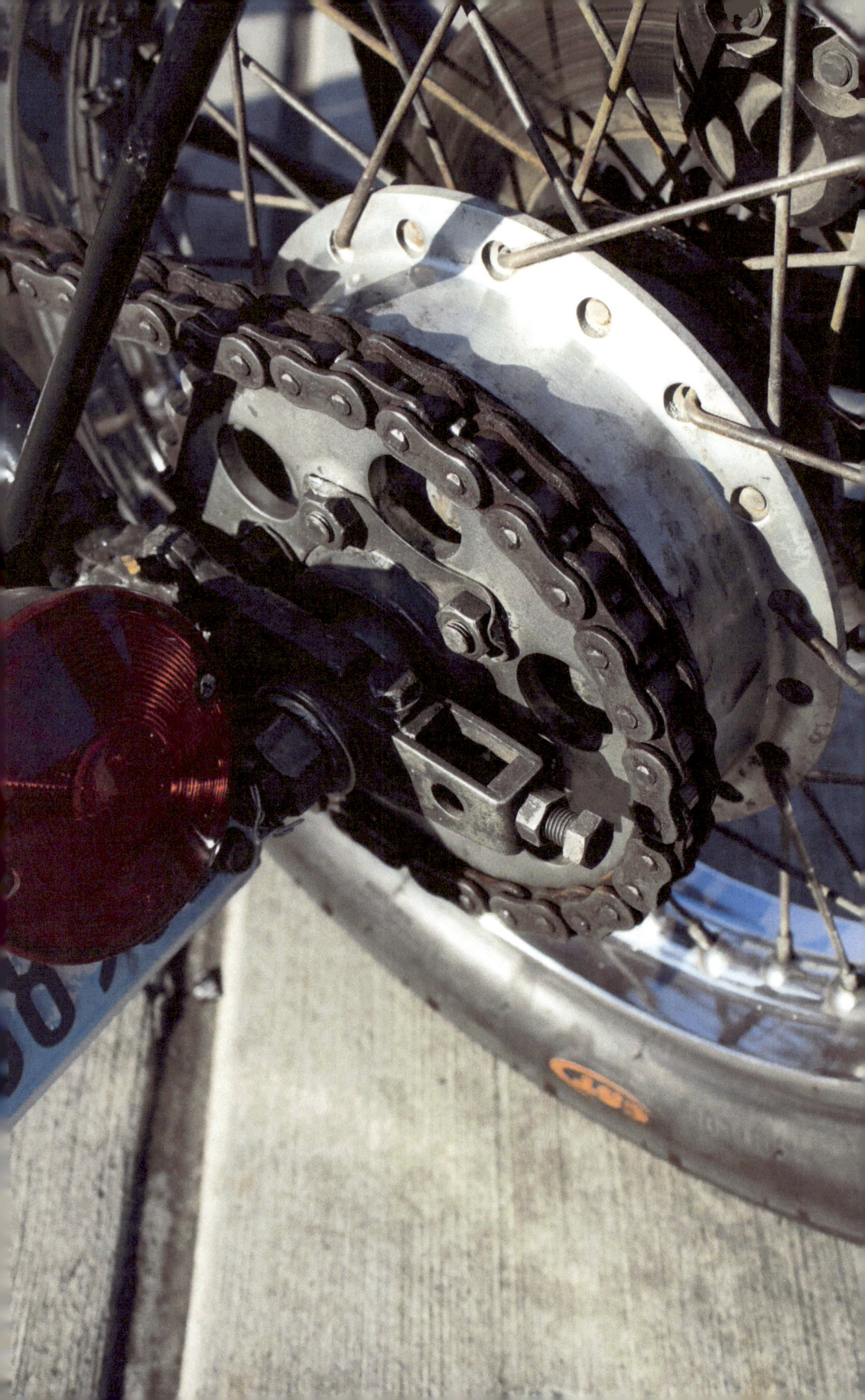

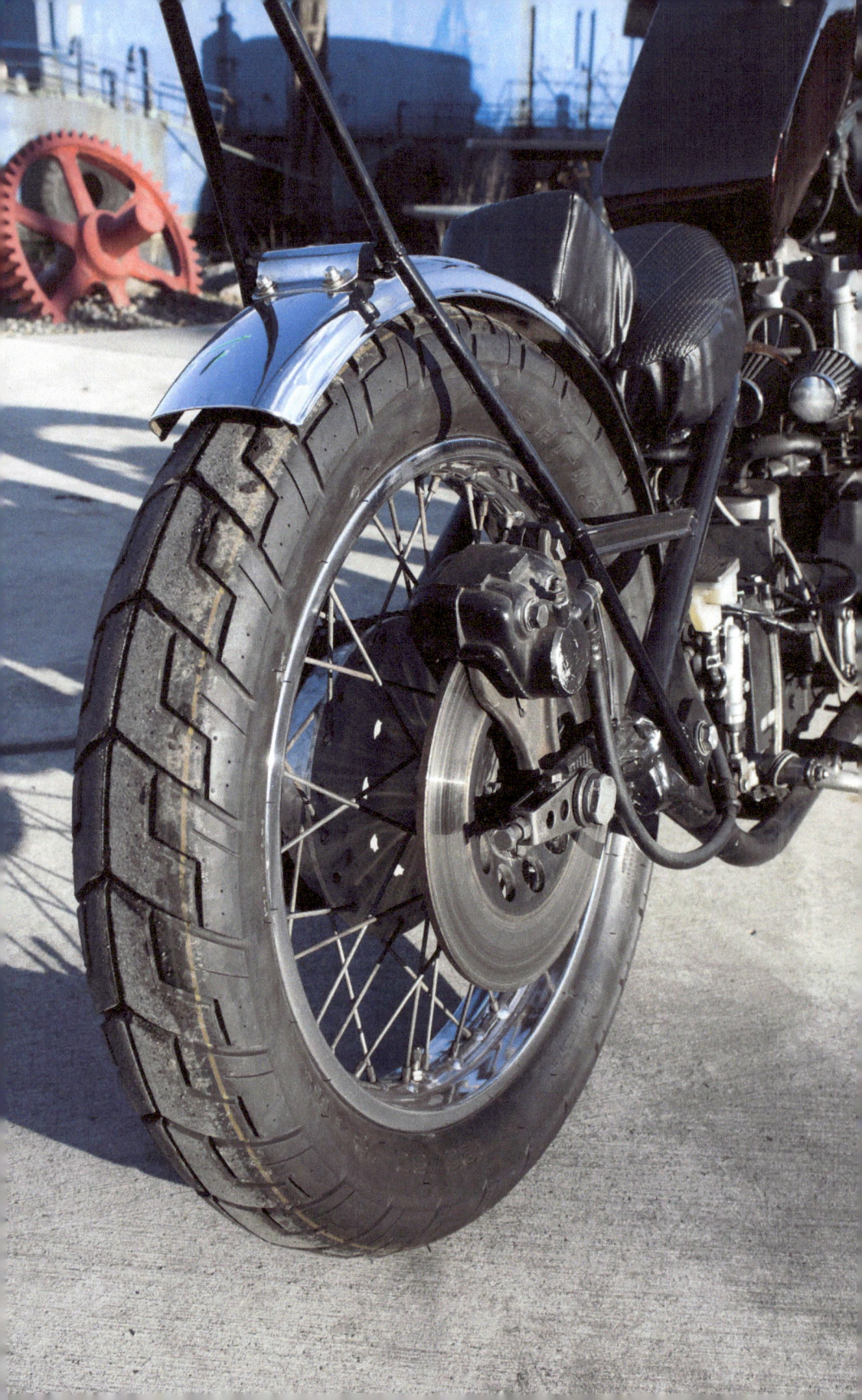

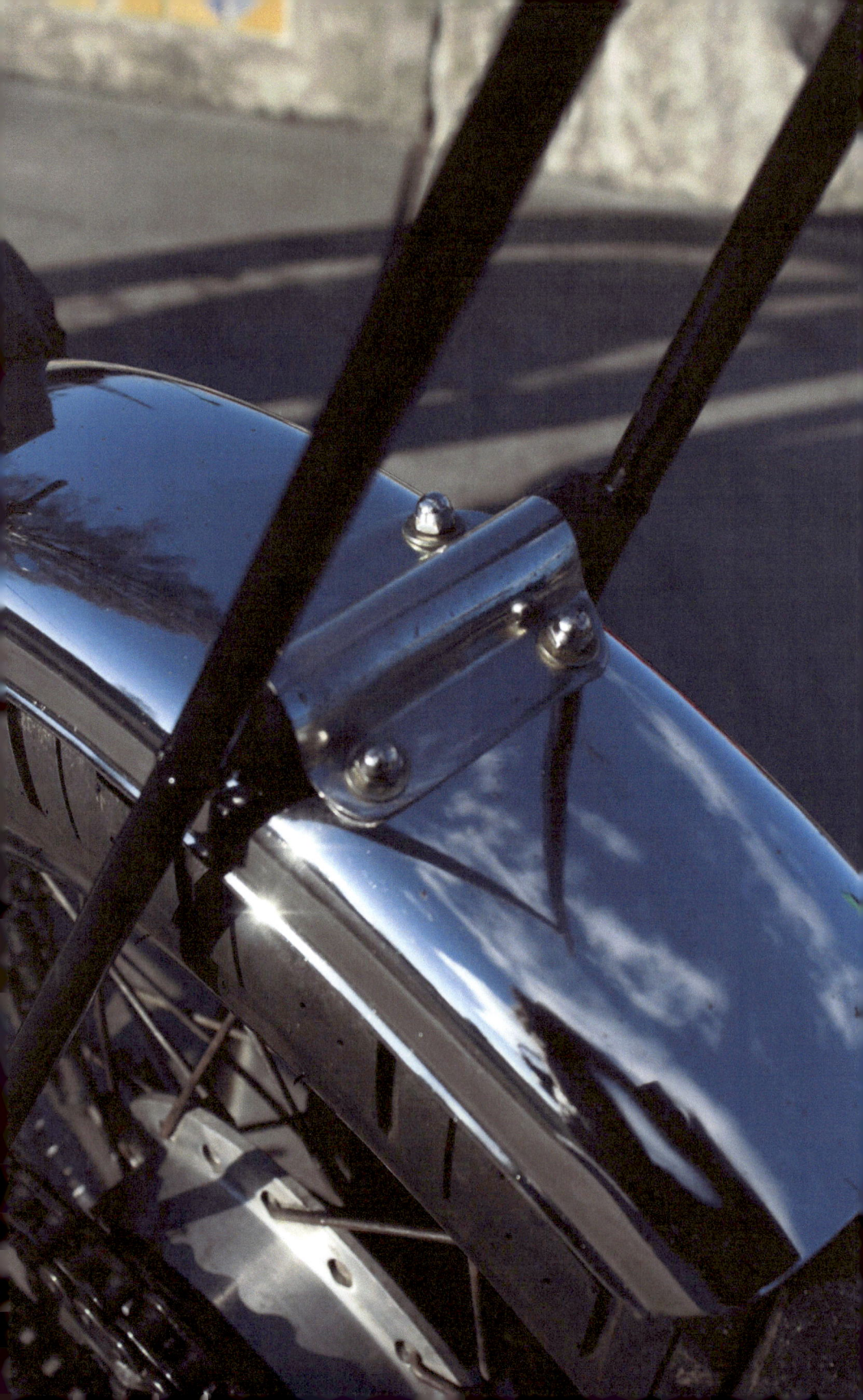

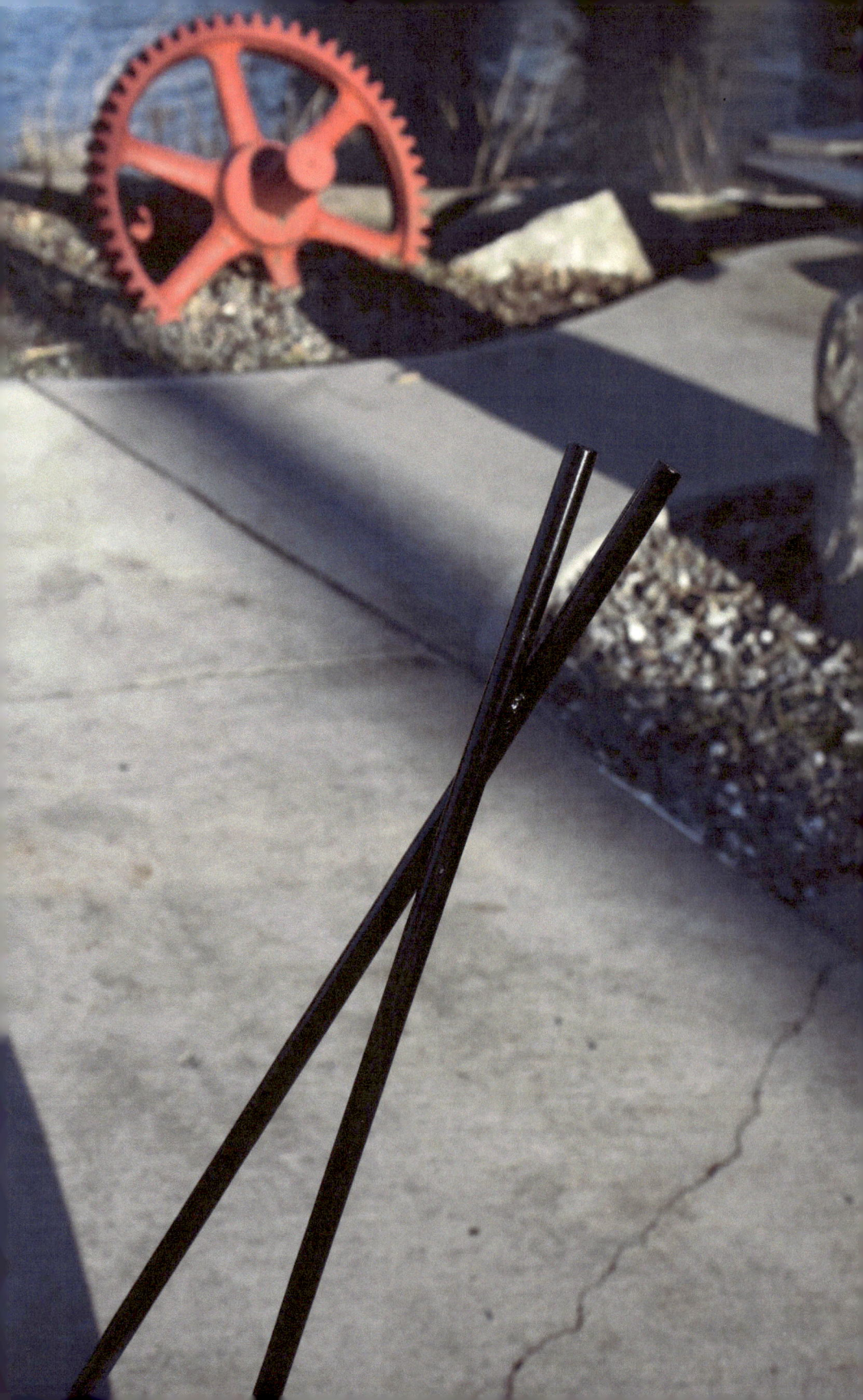

go to chriskentart.com

www.ingramcontent.com/pod-product-compliance
Lightning Source LLC
Chambersburg PA
CBHW041133200526
45172CB00018B/311